Calligraphy

For Creative Kids

(and adults too!)

Other Books by Jim Bennett

You Can Do Calligraphy

Calligraphy For Dummies

Calligraphy

For Creative Kids

(and adults too!)

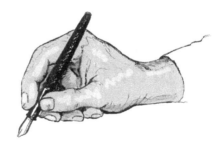

Jim Bennett

Riverflow Press, 2012

First printing 2012

ISBN 978-1-105-88105-3

Contents

Certainly
The Art of Writing
is the most miraculous
of all things CARLYLE
man has devised.

Using the Right Tools

Choosing Your Pen(s)

You have a choice of three kinds of pens: **markers, fountain pens, and dip pens**. Each of these is good for particular kinds of work. Each has its advantages and disadvantages.

Markers are useful for those quick, on-the-spot jobs where you need to do some calligraphy in a hurry, such as lettering stick-on name badges. A fountain pen makes learning calligraphy easy and can also be used to create some very fine calligraphy. A dip pen will enable you to do your best quality, finished work in India ink in the largest range of sizes.

Markers

Markers are great when quality is not a consideration but time is. You wouldn't want to use a marker to letter a certificate, but a marker would be perfect for doing a quick label or a name tag.

The main advantage of markers is how handy they are. They are the ultimate no-fuss no-muss calligraphy pen. And when they run out of ink, you simply toss them in the trash.

Their limitations are many. The biggest limitation is you really cannot do good quality work with a marker; the writing tip is simply not fine enough to make the sharp edges and fine hairlines that a good pen will give you. I must add, however, that the quality of markers is constantly improving, and the markers today are far better than those of just a few years ago.

Other limitations include ink that fades with age (although that too is changing since the ZIG markers), a short life (they tend to dry out quickly), and deterioration of the tip. Even with careful use, the tips on the markers have a tendency to lose their sharpness. The chisel-edge becomes blunted with use.

I usually recommend that people not try to learn calligraphy using markers. In learning calligraphy, one needs to practice the correct way to hold the pen to produce the desired strokes and shapes. A calligraphy fountain pen or dip pen helps a person learn how to hold the pen correctly, because it will not write otherwise. The problem with the marker is it will write no matter how you hold it.

I hope I have not sounded too negative in my comments about markers. In spite of their limitations, markers are extremely useful. I use them all the time.

One tip: When you are buying markers, test them in the store first. You never know unless you test it if a marker has already dried out. Also, make sure that your markers are tightly capped when you are not using them. Use force when you recap a marker to make sure the cap is snug.

The markers I've listed here are just a few of the most reliable ones I have found. All of these markers come in a variety of colors. There are many other kinds of markers which may be just as good as or even better than these. These are simply the ones that I have found to be suitable for calligraphy. Note: all these markers are shown uncapped.

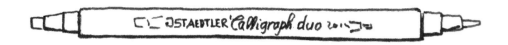

Staedtler Calligraph Duo Marker

This marker writes with either end! One end has a 2 mm chisel tip and the other a 5 mm tip. This marker comes in a variety of colors, and the ink is waterproof.

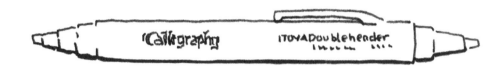

The Itoya Doubleheader

This marker also lets you write with both ends. The smaller tip is 1.7 mm and the larger one is 3.5 mm.

Niji Calligraphy Marker

The ink in this marker is especially dense. It is available in sets of 3. The tips are 2 mm, 3.5 mm, and 5 mm.

The ZIG Calligraphy Marker

This marker was designed primarily to meet the needs of scrapbookers. The ink is permanent and archival quality. There is a nice assortment of colors

as well. One end of each marker is 2 mm round for drawing and the other is 5 mm chisel shaped for calligraphy.

Speedball Elegant Writer

This marker was one of the first to be designed to approximate the calligraphy pen. The tip sizes have the names, X-Fine, Fine, Medium, and Broad.

Marvy 6000 Calligraphy Marker

This marker is my personal favorite. The tip gives nice sharp lines, and the ink is dark. This marker comes in three sizes 2.0 mm, 3.5 mm, and 5.0 mm.

Fountain Pens

Fountain pens offer you several advantages. I recommend that everyone beginning to learn calligraphy start with a fountain pen.

Fountain pens are excellent for practice, letter writing, and small jobs where you do not need especially large letters. You can carry your fountain pen with you so you are prepared to do some calligraphy on the spot wherever you happen to be. Fountain pens have a good selection of nib sizes

and are available with both ink cartridges as well as reservoir adapters which allow you to fill your pen from a bottle of ink.

The major limitation of a fountain pen is the ink is not as dark and not as permanent as the dip pen inks. The other major drawback is that fountain pens are a little pricier than markers and dip pens.

A minor drawback is that fountain pen nib sizes have not been standardized. The most common names for the different size nibs are fine, medium, and broad, but the actual sizes can vary tremendously from one brand to another. A medium nib for one brand may be a broad nib for another brand.

There are many brands of calligraphy fountain pens currently on the market. They generally range in price from under twenty dollars to over fifty dollars.

The fountain pen that I am most impressed with is the Manuscript brand pen. It offers good quality and is inexpensive. It is also widely available in both right-handed and left-handed versions. If you are left-handed, I will explain on the next page, the choices that left-handers have.

The practice pages in this book are designed to work with the Manuscript pen. That is not to say that you cannot use other kinds of pens for the practice pages. You will just have to make sure that the nib you are using is the same size as the nib I recommend. That should be fairly easy because all the nib sizes are given in millemeter equivalents.

The nibs that you will need for the Manuscript pen are the fine, medium, broad and 2B nibs. Perhaps I'm old school, but I also believe it is a good idea to be able to fill your pen from a bottle and not rely on using

cartridges in your pen. For that reason I recommend that anyone buying the Manuscript pen also get the adapter.

Fortunately, Manuscript has several sets that contain the four nibs you will need (plus more) and the adapter. The best set I've seen is the Manuscript Calligrapher's Deluxe Set. If you can't find a set that has everything you need, you can usually get the pen in a simple set, additional nibs, and an adapter separately.

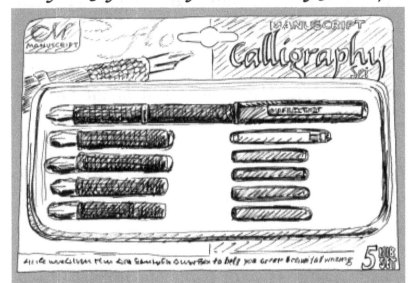

NEVER EVER use a waterproof ink in your fountain pen. Use only non-waterproof inks that are formulated especially for fountain pens.

The Manuscript 5-Nib Deluxe Calligraphy Set. This set contains a pen, five nibs, an adapter, and four cartridges.

If you are left-handed

If you are left-handed, you have a choice of whether to get a right-handed or left-handed pen. Before you buy a pen, decide which is going to be best for you.

If you are a lefty, you should choose one of the three positions that are pictured on the next page. It should be the position that is most comfortable

and easiest for you to maintain as you write. The hand position you choose will be the position, you use to do all your calligraphy.

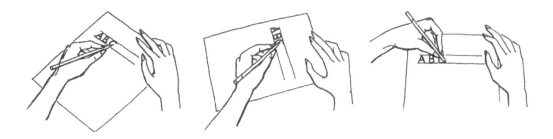

Three options for left-handers.

If you choose the position at the far left, you should get a left-oblique (left-handed) pen. If you pick either of the other two positions, you should use the same kind of pen that right-handers use.

Please note: If you select the position on the far right, you will have to use caution that you don't drag your hand through the ink.

Using a Fountain Pen

When you bought your pen it may have come in a package unassembled. Before you do any of the practice work that is shown in this workbook you will need to put the parts of the pen together, make certain that the pen has ink in it and that the ink will actually flow out of the pen onto the paper the way it should.

Putting the pen together is pretty easy, but frequently getting the pen to write is somewhat of a problem. The pen is not always one hundred percent cooperative. There is also a special way that you have to hold the pen to get it to write.

Parts of the pen

Examine your fountain pen. Take off the cap. Look over the parts.

Each part of the Manuscript fountain pen has a name, and it's helpful to know these names so that we understand what we are talking about. The fact is, you can use names like "thing-a-ma-jig" if you want to. There are no calligraphy police who will come and arrest you. However, it makes understanding each other a whole lot easier if we're all speaking the same language.

The names for the parts of the pen are: the barrel, the ink cartridge (or the adapter, depending upon which type of pen you have), the nib (no true calligrapher ever calls it a pen point), and the cap. For the practice in this book, we'll use the 2B nib which is approximately 1 ½ mm in width.

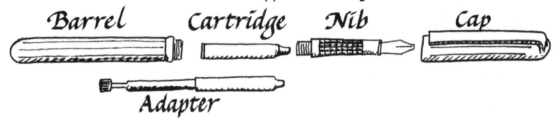

The parts of the pen: the barrel, the ink cartridge (or adapter), the nib, and the cap.

The three main, working parts of the fountain pen are:

❖**The Nib**: This is the name that calligraphers call the part of the pen that everyone else refers to as the pen point. Calligraphy nibs have a flat edge similar in appearance to a flat screwdriver and come in a variety of sizes. Markers have nibs that are permanently attached. Fountain pens have nibs that are interchangeable and screw into the barrel of the pen. They usually come in sets. Dip pens have steel nibs that slide into a curved

slot in the end of a pen handle. The selection of sizes is much bigger than for fountain pen nibs. Dip pen nibs are available individually.

❖The Cartridge: All the popular calligraphy fountain pens use ink cartridges. Cartridges are the newest addition to the design of calligraphy pens and make using the pen simple and virtually mess-free. The biggest problem with cartridges is getting the ink to flow from the cartridge down to the tip of the pen so it will write. That does not happen automatically. Sometimes you have to work at getting the pen started.

❖The Adapter: This takes the place of ink cartridges and makes it possible for you to fill your fountain pen with ink from a bottle. Perhaps I'm old school, but I believe it is a good idea to be able to fill your pen from a bottle and not rely on using cartridges in your pen. The cartridges are small and easy to misplace; the bottle isn't. Although filling the pen from a bottle has a greater potential for creating a mess than using cartridges, a pen that is filled from a bottle will start writing faster than pens that have cartridges. I recommend that anyone buying the Manuscript pen also gets the adapter and a bottle of ink.

Fill'er up! Filling the pen

If you are using a cartridge pen, first notice that the cartridge has two different ends. You want to have the cartridge headed the right direction when you put it into the barrel. Also notice that the pen requires that you insert two cartridges back to back (the flat ends will be touching) so that the first cartridge acts like a spacer in the barrel. Read the instructions

that came with your pen to make certain you know exactly how this works for your pen. Then simply drop the cartridge(s) into the barrel and screw on the nib. When you screw on the nib, it should puncture the cartridge just right.

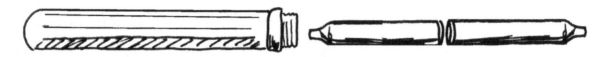

Two ink cartridges are dropped into the barrel and the nib is screwed on.

If you are using a pen with a reservoir adapter, which is my recommendation, you will need to fill it from an ink bottle. All adapters have some kind of pump mechanism. Read the instructions to see if yours is the plunger type or the kind you squeeze from the sides. The Manuscript pen has a plunger type adapter. Push it in, put the nib into the ink, and slowly pull the plunger out.

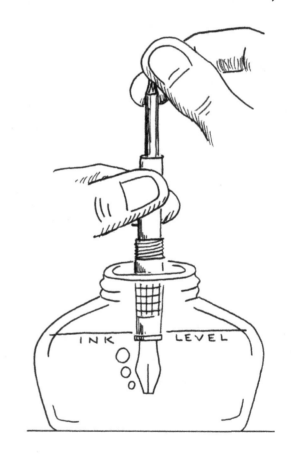

When you fill the pen, it is best to submerge only the nib into the ink. Otherwise, you might have a little mess. Once the pen is filled, wipe away the excess ink.

Pen Hold

If you are accustomed to writing with a ballpoint pen, you may have acquired a few not-so-good writing habits. This most common is gripping the pen too tightly. A tense pen hold can be inhibiting to the kind of control you will need to do calligraphy. It can also quickly produce fatigue or writer's cramp.

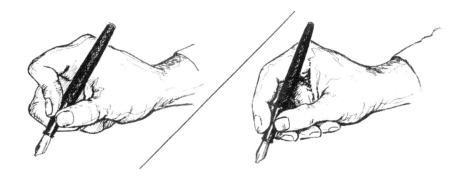

A tense pen hold compared to the ideal pen hold.

The tense pen hold has the index finger angled upward and the middle, ring, and little fingers are curved tightly into the palm of the hand. If your habit is to hold the pen anything like this, I encourage you to make an effort to relax and work on developing a new habit.

The ideal pen hold is firm but relaxed. The index finger is curved just slightly, and the middle, ring, and little fingers are curved gently underneath.

Please study this illustration of the correct way to hold the pen. Practice positioning your fingers like the ones shown as well as angling the pen exactly as shown in the picture.

Ink flow problems

The first thing you must do is see if you can get the pen to write. If you are using a cartridge pen, it is entirely normal for the pen to refuse to write immediately. The challenge is getting the ink out of the cartridge, down into the nib, and onto the paper.

Hold the pen loosely with the nib pointed downward about two inches above a sheet of scratch paper. Tap the nib lightly on the paper several times. Avoid jabbing the pen into the paper – just let it slide through your fingers of its own weight. The idea is to coax the ink to flow down into the nib.

See if your pen will write when you hold the nib flush against the paper as shown in the illustration below and move the pen side to side. Also, being very careful that you don't bend the nib, you can apply a tiny bit of pressure against the paper as you draw the nib toward you.

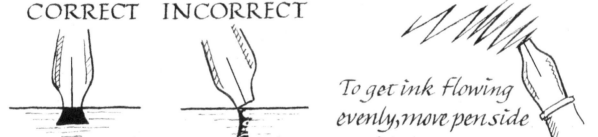

CORRECT INCORRECT

To get ink flowing evenly, move pen side to side –

Getting the pen to write – make certain the flat edge of the nib is held flush against the surface of the paper. Move it side to side. Keep the pressure even.

If none of these methods work, I have an almost no-fail technique for getting a cartridge pen started. Just unscrew the barrel and give the cartridge a little squeeze until you see a small droplet of ink form at the

back of the nib. Make sure you do this while you are holding the pen over a surface that won't be harmed if you squeeze a bit too hard and the drop of ink accidentally goes splat onto whatever is underneath!

Once you get the pen working the first time, it should be easier to get it going the next time you use it. There is definitely a "break-in" process. If you have trouble with your pen, treat it like a balky child; be gentle and persistent and never lose your cool.

Sometimes a nib is particularly uncooperative (probably because there is an oily film on the nib). If you run into that situation, simply wipe the nib with ammonia. That should cure what ails it!

Presto-Chango! The Pen Is the "Calligrapher's Magic Wand"

The calligraphy pen has a special flat point, sometimes called a chisel-edge or broad-edge, and it's this special edge that creates the beautiful ribbon-like appearance of real calligraphy where some parts of the letters are thick and other parts are thin. The pen makes all those beautiful "thicks" and "thins" automatically.

The pen will automatically give the letters the distinctive "ribbon" look of real calligraphy.

As you practice the alphabets in this book, there will be instructions on how to hold the pen. Just learn the special ways to hold the pen, and the pen

will do all the rest. The pen "knows" exactly where to put those fancy "thicks" and "thins." You don't have to figure out where they go. It's amazing. It works like magic! That's why I call the pen the "calligrapher's magic wand."

Through Thick and Thin

Discover what your pen can do. Have fun and experiment. Makes some marks and doodles. Look at the kinds of marks you can make with the pen. It's amazing! See if you can duplicate the five doodles below. Copy them in the spaces provided. Can you create some interesting doodles of your own? See what you can do.

Doodles. See if you can copy these.

How would you hold the pen to make the fattest possible line? Make a fat line in the space below.

How would you hold the pen to make the thinnest line? Make a thin line in the space below.

_____ _____

Turn the pen so you can duplicate the thick and thin lines shown here.

Taking Care of Your Fountain Pen

Using non-waterproof ink in your pen makes taking care of your pen incredibly easy. In fact, there is nothing special that you will have to do at all. When you change nibs and before you put the old nib away, you may wipe the old nib with a soft paper towel to clean off the excess ink if you want to, but you really don t even have to do that. If the ink dries in your pen, usually all you have to do is refill the pen and you are set to go again. If for any reason, you feel that you should rinse the nib, just run it under warm water or let it soak in a small bowl of water and then dry it with a clean, soft paper towel. Don t ever use any soap or cleanser on the interior parts of the fountain pen.

Dip Pens

The main advantage of the dip pen is that it will allow you to use inks which you cannot use in a fountain pen. Dip pens will also enable you to produce a much finer quality calligraphy in terms of sharp, crisp looking letters.

Dip pens are inexpensive, are easy to take care of, and will last for years. The dip pen nibs that I use are about thirty years old and show no signs of wearing out. The only things that I've ever had to replace are the handles.

When it comes to listing the disadvantages of dip pens, I can really only think of one — the dip pen is not something that you can carry around in your pocket or purse very easily (or very safely). As an example, a student of mine put her pens and ink in her purse to bring them to class. The only problem was that top on the bottle of ink was not screwed tightly. You can imagine the mess she had when she got to class and opened her purse!

Select your pen according to the nib. I can recommend that you choose from three kinds of broad edged nibs Mitchell type nibs, Brause nibs, or Speedball C-series nibs. All three of these are available in right and left-handed versions.

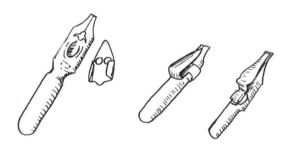

The Michell type nib with the reservoir, the Brause nib, and the Speedball C-series nib.

Mitchell Roundhand

The Mitchell Roundhand nib is my first choice. This nib has a wonderfully soft touch. It is a nib that requires very little pressure. It is a pleasure to use.

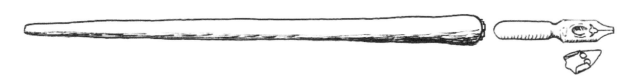

The Mitchell Roundhand type nib is steel and has a dimple in the top for filling with ink (I explain how in the next chapter). It also has a brass reservoir which attaches underneath the nib. The brass is soft enough that you can easily fit it to the nib.

You should get a complete set of these nibs with a reservoir for each nib. The first thing you should do is check the fit of the reservoir. It should slide onto the nib snugly. The tongue of the reservoir should touch the underneath side of the nib close to the broad edge.

Manuscript also manufactures a nib that looks exactly like the Mitchell Roundhand nib. They call this pen the Chronicle. It is available in sets with a nice wooden handle.

Brause

This is also a steel nib. The reservoir which is also steel is on top. The Brause nib has a firmer feel than the Mitchell nib. If you have a tendency to press down, Brause is probably a better choice.

Speedball C-Series

This steel nib has a brass reservoir permanently attached to the top. If you get this nib, make sure that the reservoir is not flat against the nib. It should be slightly raised in the middle so it can hold ink.

Since you cannot take this nib apart to wipe it clean, you will have to rinse the nib thoroughly under running water and dry it completely after you use it.

Handles

Select a handle that fits your nibs and feels comfortable in your hand. Varnished wooden handles are the best choice. Plastic is okay. Avoid painted handles, because the paint will eventually chip away.

Got The Right Ink?

Buying ink is simple if you remember one simple thing – don't use waterproof ink. Use only non-waterproof inks.

An excellent ink for fountain pens is Pelikan 4001 ink. This ink will not clog your pen and flows easily. It is a dye ink which means that it is not as dark and opaque as a carbon pigment ink, but it is still an excellent ink that is recognized by calligraphers around the world.

I'm going to make two recommendations for dip pen ink Higgins Eternal black ink (sometimes humorously called Higgins Infernal) and Pelikan Fount India. The Fount India has the advantage of coming with a dropper stopper which is handy for filling the pen.

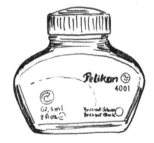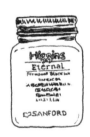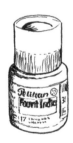

3 inks: Pelikan 4001, Higgins Eternal, and Pelikan Fount India.

Filling the dip pen

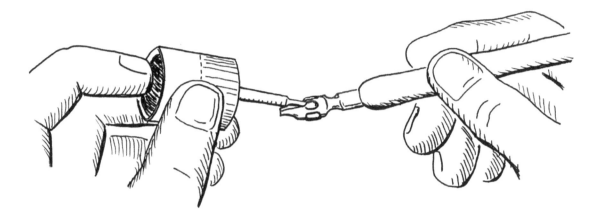

Before you try to fill the pen, make sure that the little reservoir is bent correctly so it touches the back of the nib very close to the flat edge. Also make certain that the reservoir is snug so it won't slide accidentally on the nib. If you are using a Brause pen, the reservoir is on top of the nib, but everything else is basically the same.

Filling this pen is easy if you know the trick. Although we call it a dip pen, I don't recommend that you actually dip it in the ink. Instead, use a small round brush or a dropper stopper (like the one that comes on the Pelikan Fount India ink bottle) to place a droplet of ink in the dimple that's on top of the pen nib. Then tap the handle of the pen once lightly on a hard surface. If done correctly, the drop of ink will pop down into the reservoir underneath, and you are ready to write.

If you are using a different kind of pen such as Brause and Speedball, simply insert a drop of ink from the side. Don't overfill, and, if you are using a dropper-stopper, watch out for air bubbles when filling they have a way of impersonating ink drops!

Selecting the Right Paper

If you are just starting out, you will need practice paper. A good quality photocopy paper usually works very well.

When you are trying to select paper, it works best if you can actually test the paper with your pen. Many papers have a soft surface, and the ink will bleed. What you want is a paper on which your calligraphy will look sharp and crisp.

The thickness of the paper is an important consideration. If the paper is translucent enough, you can use a sheet with guide lines underneath. Otherwise, you will have to draw guide lines on the paper in pencil and erase them when you are finished.

If you want paper that is larger than standard letter size, Strathmore 300 and 400 series paper is reasonably priced and comes in pads.

A higher quality paper which comes in various size pads is Pentalic Paper for Pens. This is an archival quality paper that has a smooth, hard surface. It is excellent for all kinds of calligraphy including Copperplate.

You Might Also Need...

Following is a list of additional materials that you will probably find useful in doing calligraphy. This list does not include other art materials that you may want to incorporate into your calligraphy. For example, if you do watercolor painting, you would certainly want to use watercolors together with your calligraphy.

Pencils. You will definitely need a few, good quality, hard lead pencils.

Erasers. Don't get a pink eraser; get a white eraser that does a good job erasing pencil but is not abrasive too the paper. Magic Rub and Staedtler are my favorites.

Drafting tape. This tape looks like masking tape, but it isn't as sticky. You can remove it without tearing your paper. Use drafting tape to hold your paper in position.

18 X 24 inch (or larger) rectangular board. A lap board or drawing board is real a necessity. You need to be able to tilt your work surface so you can see what you are doing straight on not from an angle. Masonite boards are a favorite.

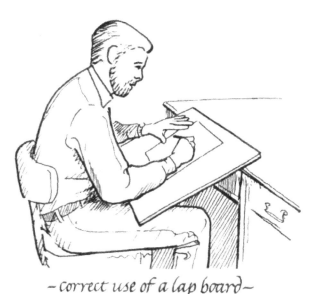
– correct use of a lap board –

The illustration on the left shows me demonstrating the correct way to use a lap board, tilted at an angle.

24 inch T-square. A T-square is needed for drawing guide lines.

Inch and metric ruler. A ruler is needed for design and placement.

30 x 60 plastic triangle. A triangle is useful in drawing guide lines.

Paper towels. Keep paper towels handy for clean up.

Taking Care of Your Materials

Calligraphy materials are really easy to take care of. Follow these few suggestions and your materials should last for years.

When you are finished, always take a few minutes for clean-up and putting things away.

Plastic boxes with compartments are great for storing nibs and small items.

If ink ever dries in one of your fountain pen nibs, it can be soaked overnight in water and dried. Usually, this is not totally necessary especially if you are using Pelikan 4001 fountain pen ink. If the ink ever dries in one of my pens, I simply refill the pen from the bottle, and it's ready to go!

Toothpaste is great for gently scrubbing dip pen nibs when they are new and have oil on them from the factory and anytime they become encrusted with dried ink.

Most dip pen nibs, especially the ones that you can take apart, can simply be wiped clean and stored in a dry place. I rarely wash my dip pen nibs.

The enemies of paper are moisture and pests. Store your paper in a place that's dry and free of mice and insects that eat paper. Also, store your paper flat so it doesn't acquire a bend in it.

The Calligrapher's Magic Wand!

From the Renaissance – The Italic Alphabet

We begin with the Italic alphabet – perhaps the most useful and versatile alphabet in the calligrapher's arsenal. Italic is beautiful, easy to do, and easy to read. This book is written in Italic.

What is the Pen Angle for Italic and How Do You Get It Right?

Pen angle is all about holding your pen in the best position so that the thicks and thins that the pen makes will appear in the correct places when you are making the letters. Pen angle is pretty easy with Italic, because you hold your pen in just one position for all the letters. The pen angle is always the same – 45 degrees. 45 degrees is fairly natural for most people.

To do Italic, the pen is not twisted and turned this way and that. It is held in one constant position as the hand and arm move it on the paper.

If you're right-handed

The drawing on the facing page shows what the correct pen angle looks like for a right-hander. The pen does not point directly back toward you, and it doesn't point out to the side. I try to imagine that the back of the pen is pointing just past my right shoulder.

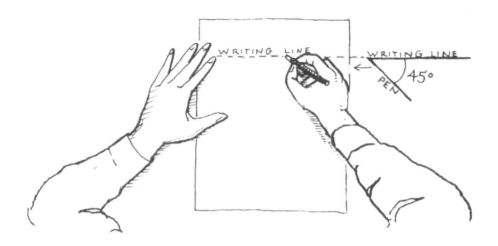

The correct pen and hand position if you are right-handed. Imagine that the back of the pen is pointing a few inches to the right of your right shoulder. Hold your pen just like this as you draw the letters.

Lefties have three options

If you are a lefty, you should choose one of the three positions that are pictured on page 7.

Do the zigzag design

The correct pen angle for Italic will enable you to make a zigzag design where the thicks and thins alternate. Study the example at the top of the next page. Then trace the zigzag on the second line and copy it on the third line.

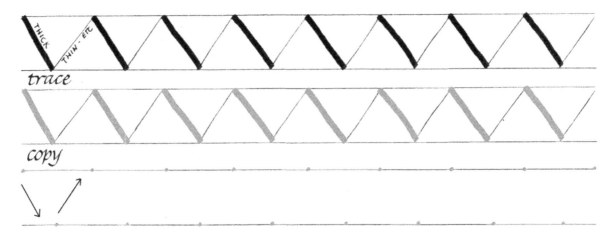

trace

copy

Hold That Pen Angle!

The pen angle that you used to make the zigzag design is the pen angle that you should use for Italic. The next practice exercise will help you perfect the angle

Doing the Plus Signs

Hold your pen in the same position that enabled you to make the zigzag, and you should be able to make plus signs that have a horizontal bar and a vertical bar that are both of medium thickness and exactly the same width. Trace over the pus signs that are drawn in gray and after each one copy in the blank spaces that follow the ones you traced.

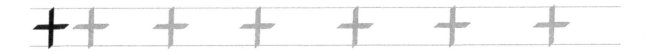

When you did the plus signs, were the horizontals and verticals equal in width? Did you notice an interesting thing happened? If you were holding

the pen correctly, the beginnings and the ends of the strokes are all slanted at exactly 45 degrees.

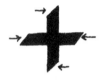 The horizontal and the vertical strokes should be equal in thickness. The beginnings and endings of these strokes should be slanted.

Are your strokes angled like the ones in the illustration?

Check the plus signs that you made. Are the strokes angled at the beginnings and ends? If yours are not, then try again. Make whatever adjustments are necessary to correct it. Use the lines below to practice the plus signs.

Doing the Six Basic Shapes with a Pen

When you feel confident that you have this pen angle thing under control, try your hand at alternating tracing and copying the basic shapes for the Italic letters. First look at the examples that are drawn in black. Then trace over the gray shapes and copy in the blank spaces.

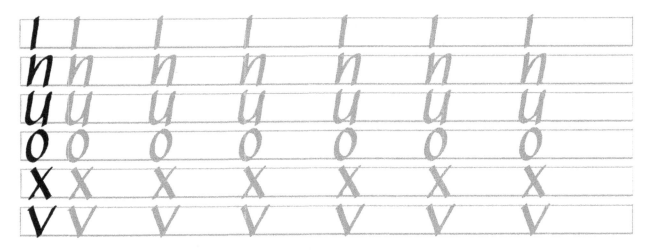

I know I have gone into great detail on this subject, but the correct pen angle is absolutely vital to doing the Italic alphabet correctly. If you don't get the pen angle right, everything else you try to do from this point on will be seriously flawed. If that happens, you would have to come back to this section and do the practice all over until you get it right. So, please don't go beyond this point until you have mastered pen angle!

Towing the Line

You need some information about the guide lines that we use. Each of these guide lines has a name. Knowing the names helps when we try to describe the letters. The top line is called the ascender line because the tops of tall letters like d go up to this line. The next line is called the waist line. The line under that is called the writing line or the base line. That's the one where the letters sit. The bottom line is called the descender line because that's where the descenders on letters like g end.

Also, the spaces between the lines for the Italic alphabet are equal to five pen widths. If you turn the pen sideways and make five little marks, one on top of the other like a stack of little "bricks," you will measure the precise distance between the lines.

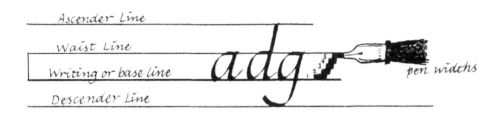

The guide lines are called the ascender line, the waist line, the base or writing line, and the descender line. The distance between the lines for this style is five pen widths.

Remember that the letters are not written INSIDE the guide lines. Look carefully at the tops of the a and g in the example, and you will see that they are actually written just slightly ON TOP OF the lines. So, the rule is this: don't write inside the guide lines but on top of the guide lines. Ideally, your strokes should cover the lines but not really go too far over the lines. (I confess – I have a tendency to go past the lines!)

Those Tails Called "Serifs" – Don't Get Caught by the Tails!

EEEK!

The tails that appear at the beginnings and endings of some of the letters are called serifs. Pay attention to the fact that there are different kinds of serifs on the letters. It is really important that you use the correct serifs with each letter.

29

Most of the serifs at the beginnings of letters are sharply pointed:

→ *i j p t u v w y*

Only 3, *m n r* , begin with an elbow-like curve:

All the serifs at the endings of letters have elbow curves.

a d h i k l m n t u

Round serifs are all *wrong.* They disrupt the rhythm.

Italic

Using a calligraphy pen or a marker with a nib 1.5 – 2 mm wide, practice the alphabet and numbers. First study the letter written in black. That is the model to follow. Second, trace over the first letter that is written in gray, and then copy it in the space that comes after the gray letter. Alternate tracing & copying each letter.

a a a a a a

b b b b b b

c c c c c c c

d d d d d d d

e e e e e e e

f f f f f f f

g g g g g g g

h h h h h h h

ĩ ĩ ĩ ĩ ĩ ĩ ĩ ĩ

j̃ j̃ j̃ j̃ j̃ j̃ j̃

k k k k k k

l l l l l l l

m m m m m m

n n n n n n

o o o o o o o

p p p p p p p

q q q q q q q

r r r r r r r

s s s s s s s

t t t t t t t

u u u u u u

v v v v v v

w w w w w w

x x x x x x

y y y y y y

z z z z z z

A A A A A

B B B B B

C C C C C

D D D D D

E E E E E

F F F F F

G G G G G G

H H H H H

I I I I I I I

J J J J J J

K K K K K K

L L L L L L L

M M M M M M

N N N N N N

O O O O O O

P P P P P P

Q Q Q Q Q Q

R R R R R R

S S S S S S

T T T T T T

U U U U U U

V V V V V V

W W W W W W

X X X X X X

y y y y y y y y

z z z z z z z z

1 1 1 1 1 1 1

2 2 2 2 2 2

3 3 3 3 3 3

4 4 4 4 4 4

5 5 5 5 5 5

6 6 6 6 6 6

7 7 7 7 7 7

8 8 8 8 8 8

9 9 9 9 9 9

0 0 0 0 0 0

Practice writing words. Trace one line and then copy on the next line. Keep the spacing like the examples.

Abe Barb Connie

Dan Emma Fred

Gary Hal Isaiah

June Kyle Lewis

Max Nick Ozzie

Paul Quincy Rolf

Sylvia Timothy

Ulysses Vivian

Will Xerxes Yves

Zoe 1234567890

The quick brown

fox jumps over 100

of the lazy dogs.

Now I know how

to do calligraphy!

Here is the entire Italic alphabet for easy reference:

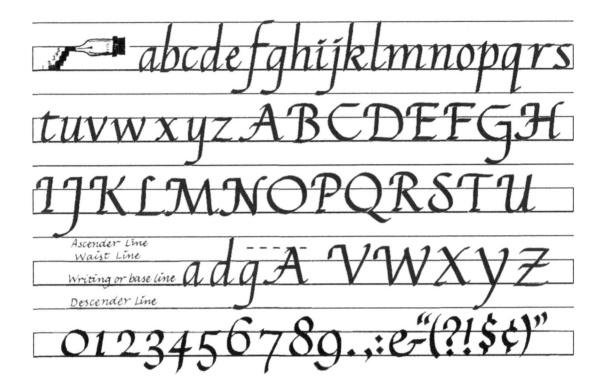

abcdefghijklmnopqrs

tuvwxyz ABCDEFGH

IJKLMNOPQRSTU

Ascender Line
Waist Line
Writing or base line adg A VWXYZ
Descender Line

0123456789.,:;e-(?!$¢)"

flourished minuscules

ape box act dandy ear

giant panda quick him

jolly fez run saying

silly risk arc crane

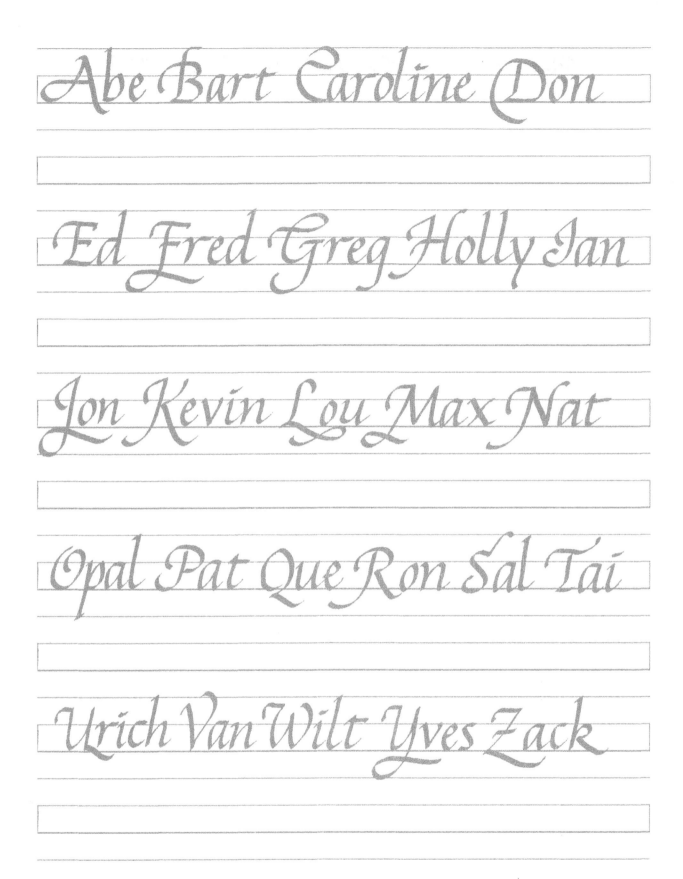

Abe Bart Caroline Don

Ed Fred Greg Holly Ian

Jon Kevin Lou Max Nat

Opal Pat Que Ron Sal Tai

Urich Van Wilt Yves Zack

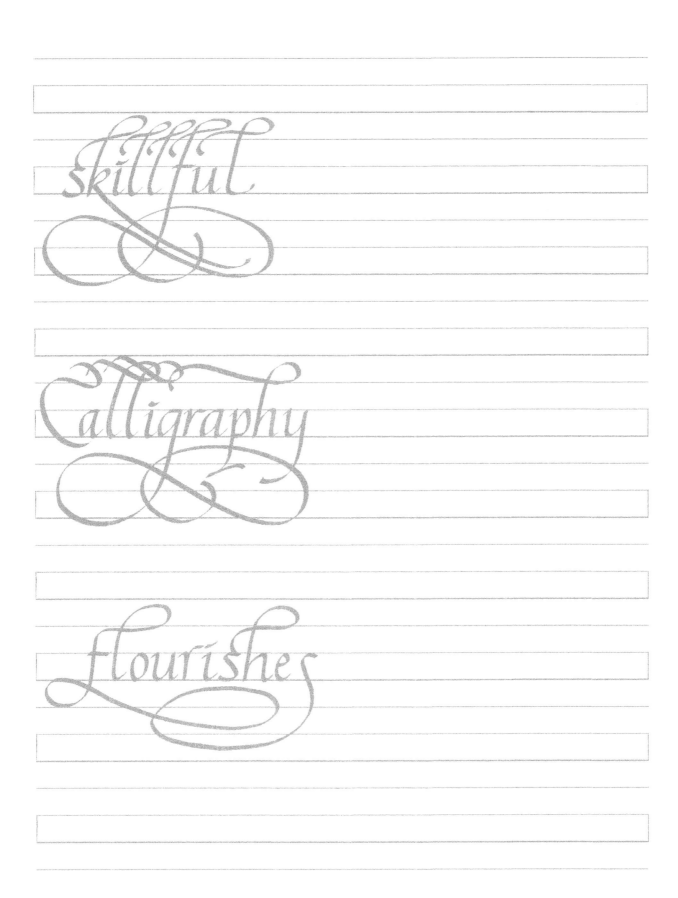

skillful

calligraphy

flourishes

For additional practice, use this page as a guide underneath your paper.

Italic B-2

From Medieval Times – Blackletter

The second alphabet we will study is called Blackletter or Gothic, a style of which 'Old English' is a highly embellished form.

For most students, the surprising thing about this difficult looking style is how remarkably easy it is for them to learn.

The reason is that the letters are all formed basically from just three simple strokes: the diamond, the vertical, and the thin diagonal.

This creates an interesting challenge which tests the calligrapher's accuracy with the pen,

especially in keeping the correct pen angle.

However, the pen angle should pose no real problem because it is the very same as you learned for Italic.

Blackletter originated with the monks and scribes of the Middle Ages, circa 1200, and was used for transcribing ecclesiastical literature.

It is called Blackletter because of the dense, black appearance which it imparts to the page.

Today, this alphabet is limited primarily to certificates and other specialized uses.

BLACKLETTER MINUSCULES

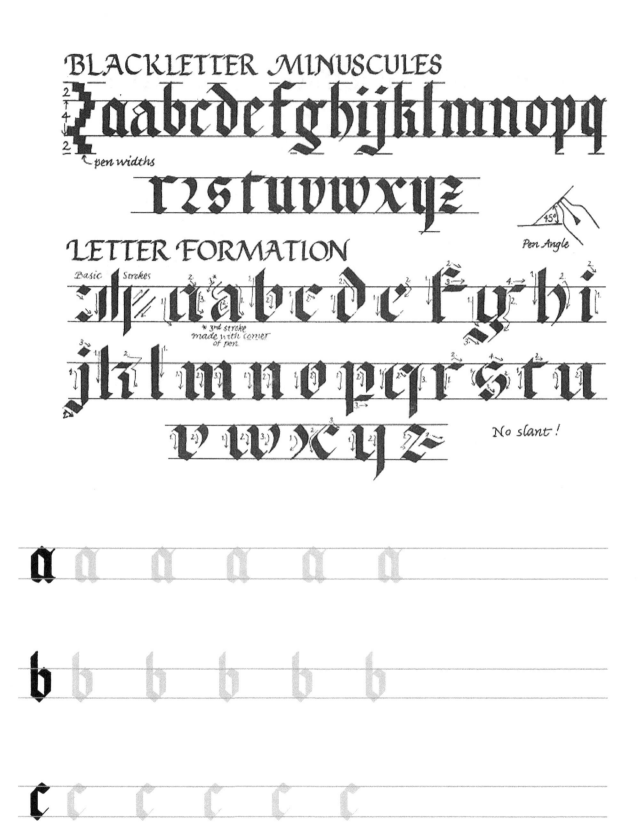

aabcdefghijklmnopq
rrstuvwxyz

pen widths

Pen Angle
45°

LETTER FORMATION

Basic Strokes uabcdefghi

* 3rd stroke
made with corner
of pen

jklmnopqrstu

vwxyz

No slant!

Y Y Y Y Y Y

Z Z Z Z Z Z

BLACKLETTER MAJUSCULES
In most cases, there is no advantage in memorizing
these capitals because they are used so infrequently.

A B C D E F G H
I J K L M N O P Q
R S T U V W X Y
Z 1 2 3 4 5 6 7 8 9 0

LETTER FORMATION

A B C D E F G
H I J K L M N
O P Q R S T
U V W X Y Z
1 2 3 4 5 6 7 8 9 0

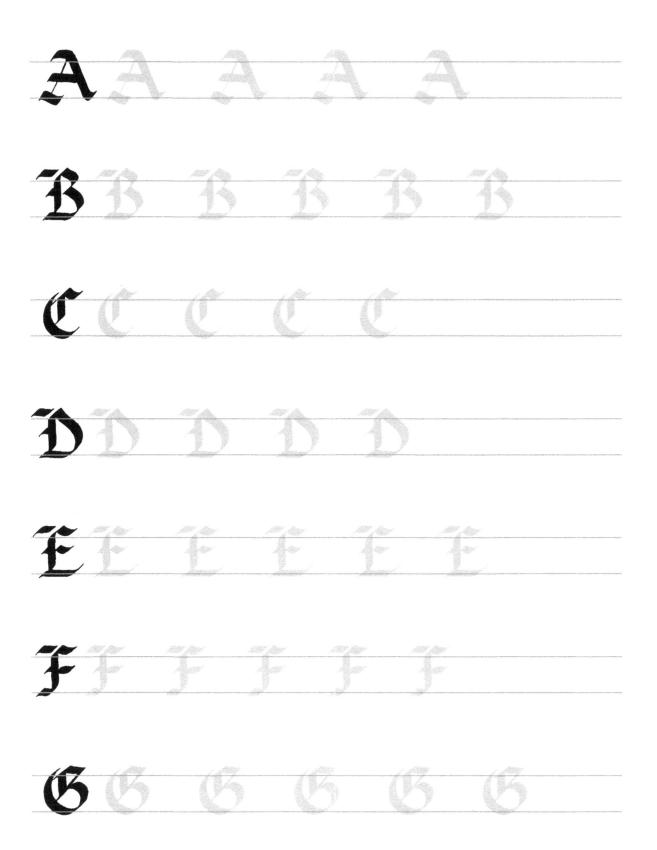

𝕳 𝕳 𝕳 𝕳 𝕳

𝕵 𝕵 𝕵 𝕵 𝕵 𝕵 𝕵

𝕴 𝕴 𝕴 𝕴 𝕴 𝕴

𝕶 𝕶 𝕶 𝕶 𝕶 𝕶

𝕷 𝕷 𝕷 𝕷 𝕷 𝕷

𝕸 𝕸 𝕸 𝕸 𝕸

𝕹 𝕹 𝕹 𝕹 𝕹

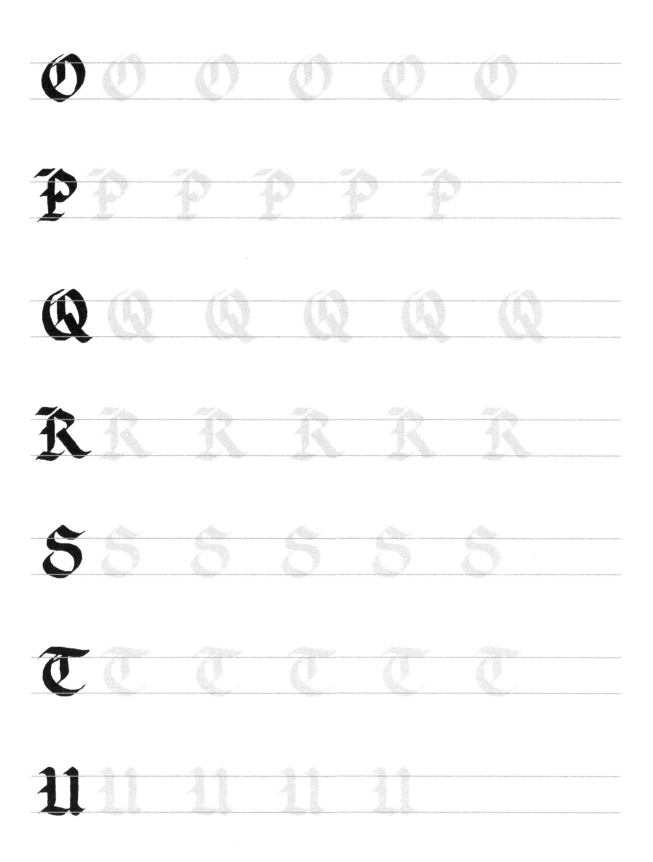

V V V V V V V

W W W W W W

X X X X X X

Y Y Y Y Y Y

Z Z Z Z Z Z

1 1 1 1 1 1

2 2 2 2 2 2

3 3 3 3 3 3

4 4 4 4 4 4

5 5 5 5 5 5

6 6 6 6 6 6

7 7 7 7 7 7

8 8 8 8 8 8

9 9 9 9 9 9

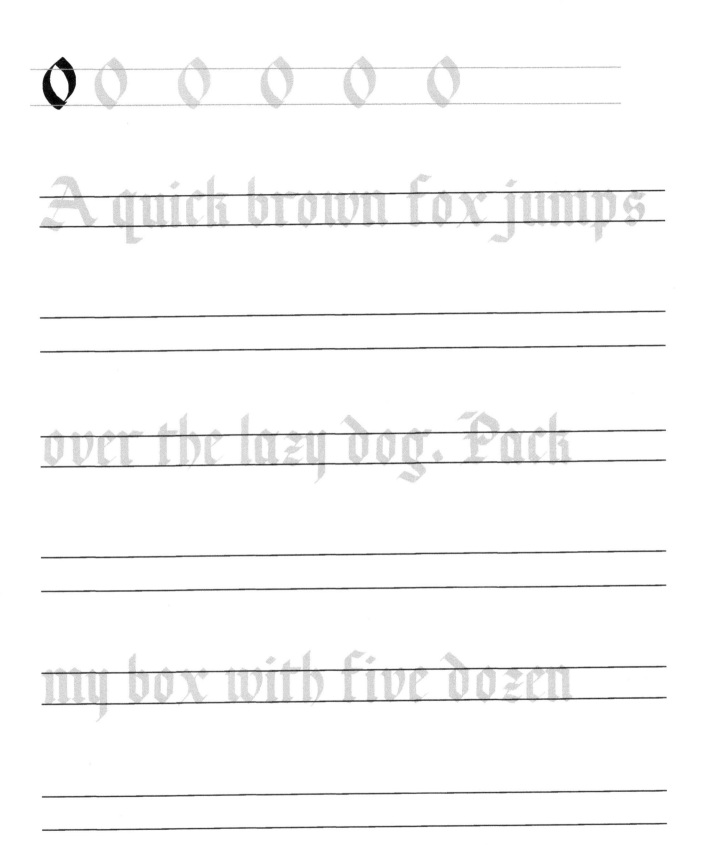

O O O O O O

A quick brown fox jumps

over the lazy dog. Pack

my box with five dozen

lacquer jugs.

Abe Barbara Connie

Dan Emma Fredrich

Gary Harold Isaiah

June Kyle Lewis

Max Nick Ozzie Paul

Quincy Rolf Sylvia

Timothy Ulysses Vivian

Will Xerxes Yves Zoe

1 2 3 4 5 6 7 8 9 0

Blackletter B 2

66

Drawn Letters

Sometimes letters are drawn and filled in. These letters can be colored. This is especially true for capital letters called "versals."

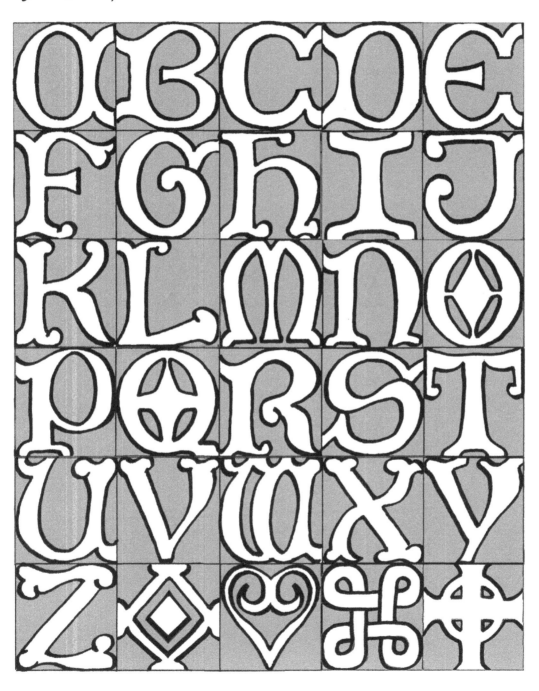

A fun alphabet.

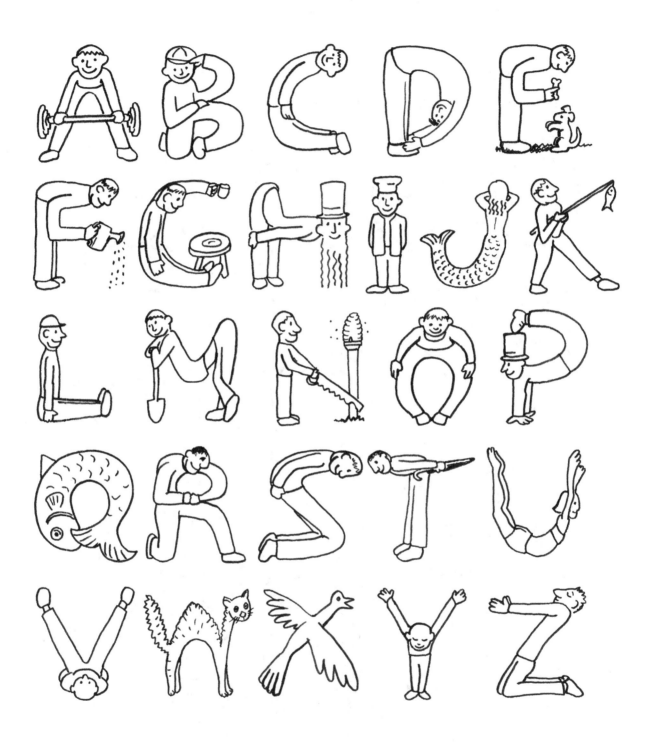

Calligraphy Projects

There are lots of things you can do with calligraphy. Here are just a few ideas for some great, creative projects for creative kids (and adults too!).

A flourished signature

A Name Badge

An Elegant Letterhead

A Folded Thank You Card (with a calligraphic design on the front)

A Custom-designed card for a Special Occasion

A Favorite Saying or Quotation which can be framed

A Personalized Scrapbook

A Story Book for a Child

A Certificate or Award for Achievement

An Impressive Door Sign

A Unique Book Plate

An Eye-catching Business Card

A Banner

Beautiful Place Cards

Labels for Spice Bottles, etc.

A Menu for a Special Dinner

An Invitation to a Very Special Occasion

An Impressive Mailing Label

An Elegantly Addressed Envelope

A Personalized Bookmark

As you can see from this partial list, there are lots of creative ways you can use calligraphy.

Go forth and be creative!